BULLSHIT

EVERYWHERE

fuck.

fuck.

fuck.

bitch.
shit.
fuck.

CUMGUZZLER

λ λ λ λ

S S S S

S S S S

h h h h

ο ο ο ο

ι ι ι ι

є є є є

GO FUCK YOURSELF

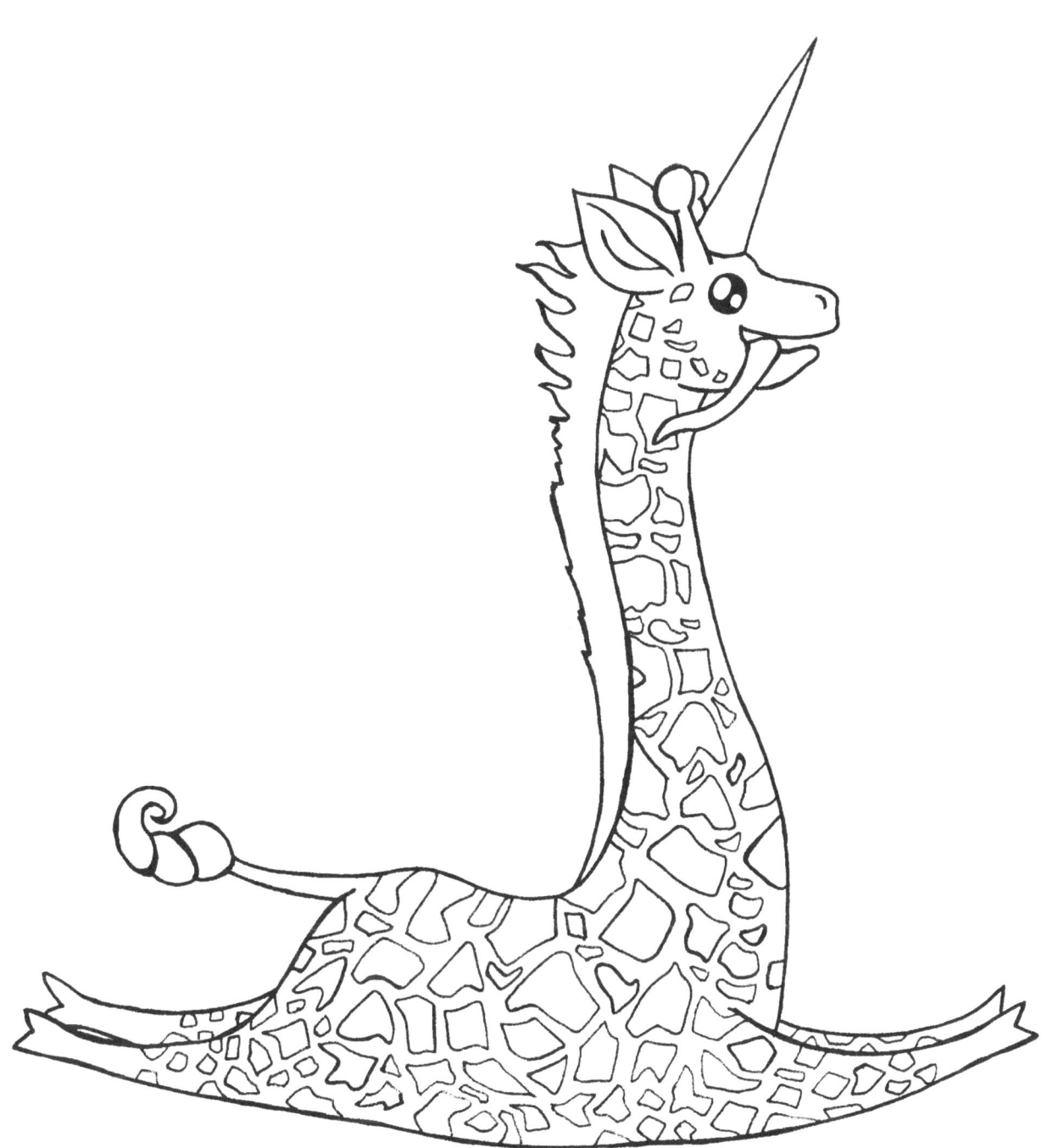

KEEP ON
FUCKIN'

PUSSY

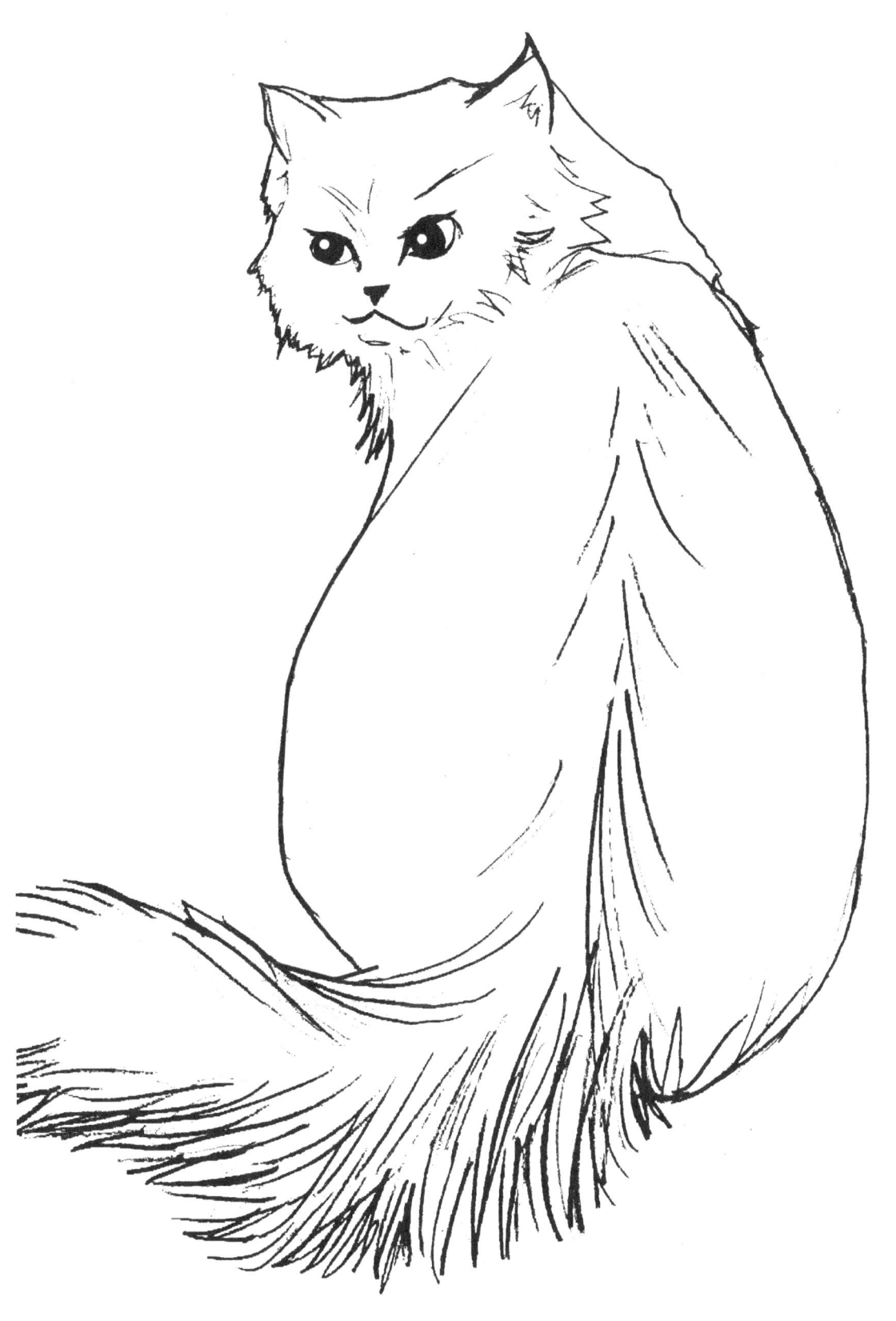

KISS MY ASS

LET THERE BE SHIT

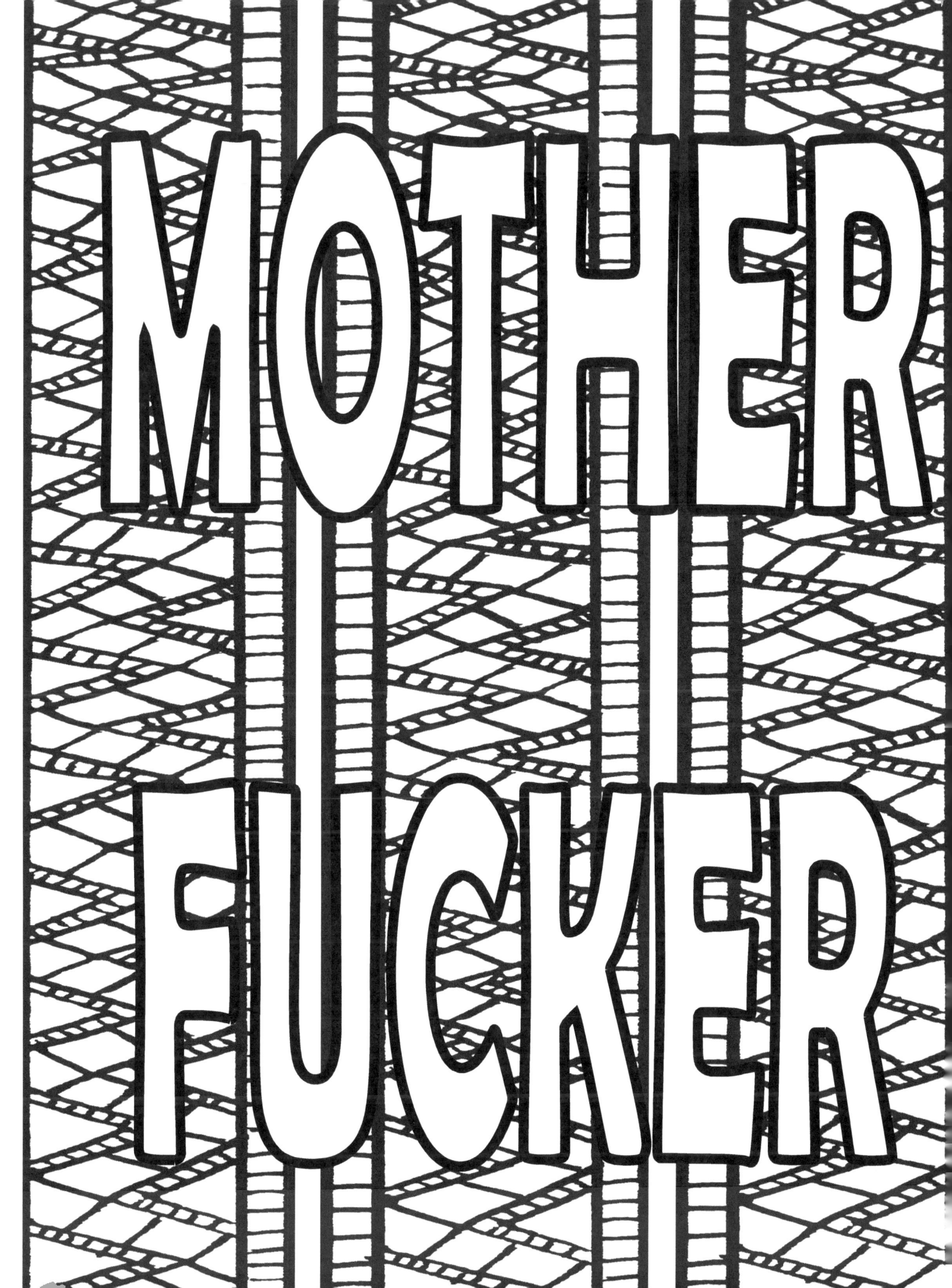

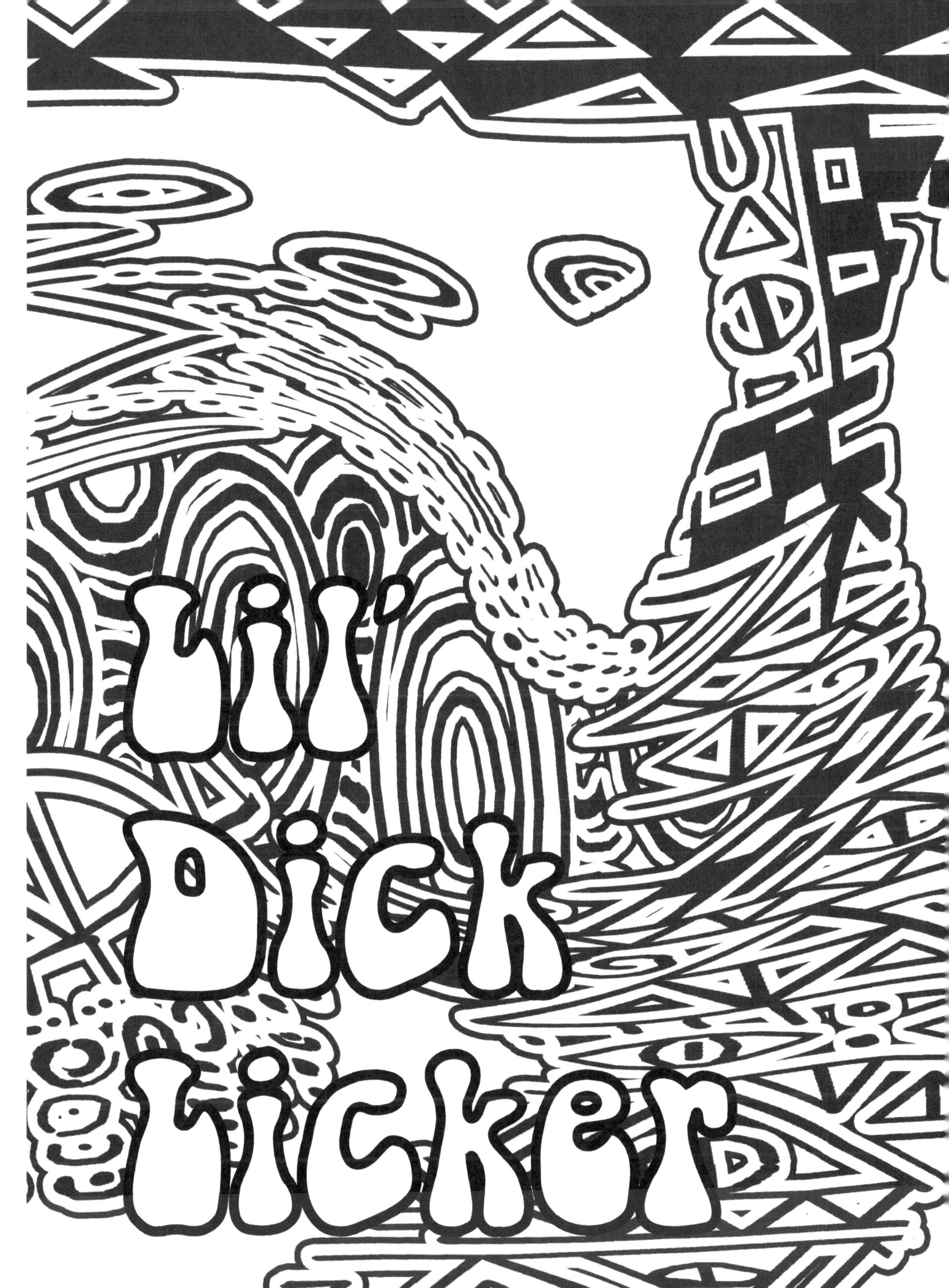

NUTSACK

ASSHAT

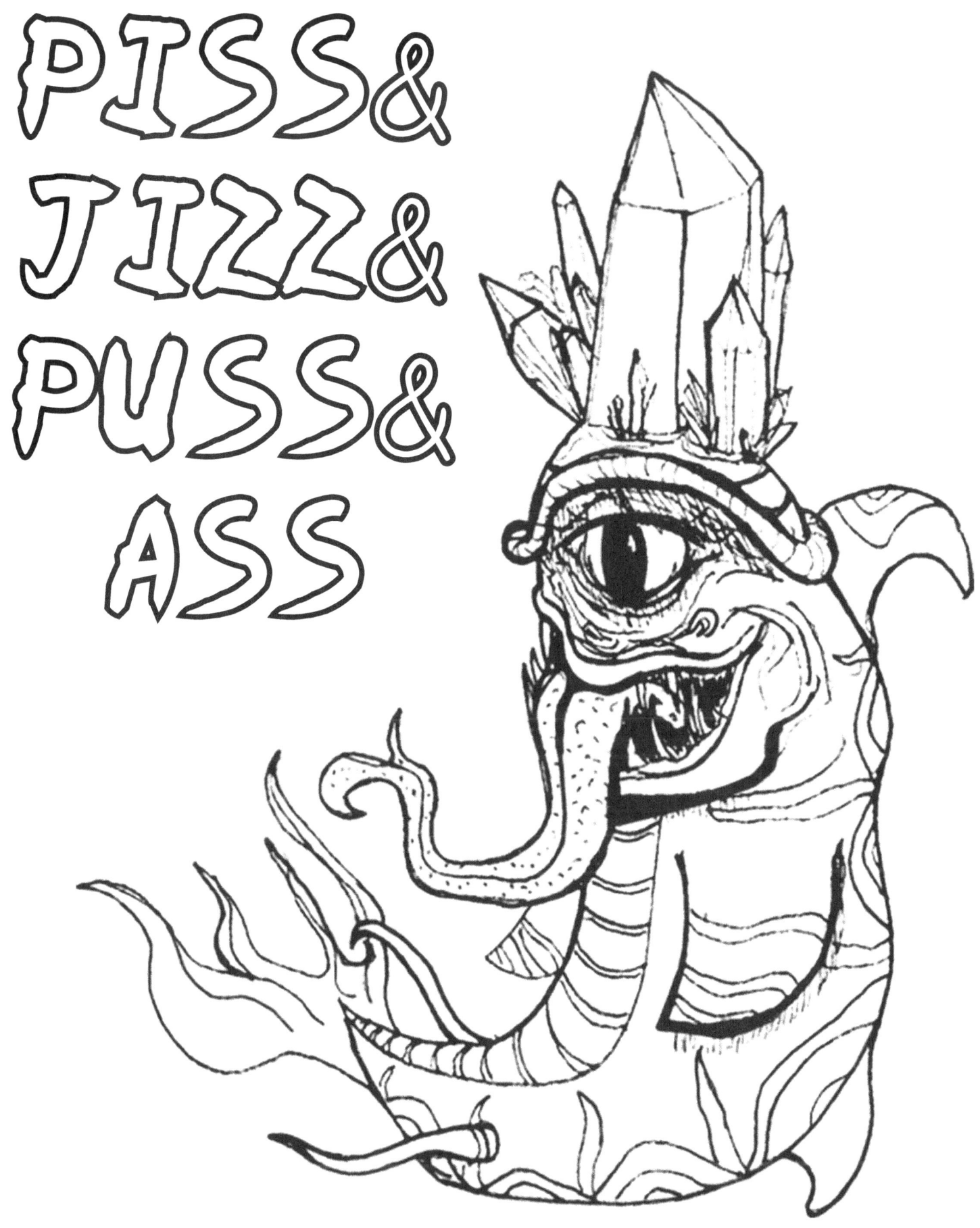

RIMJOBBING

FUCKFACE

DILDO

SWALLOWING

CLITSUCKING

DICKRIDING

BUMBLEFUCK

SHITBALLS
FUCKHEAD
COCKSUCKER
ASSHOLE

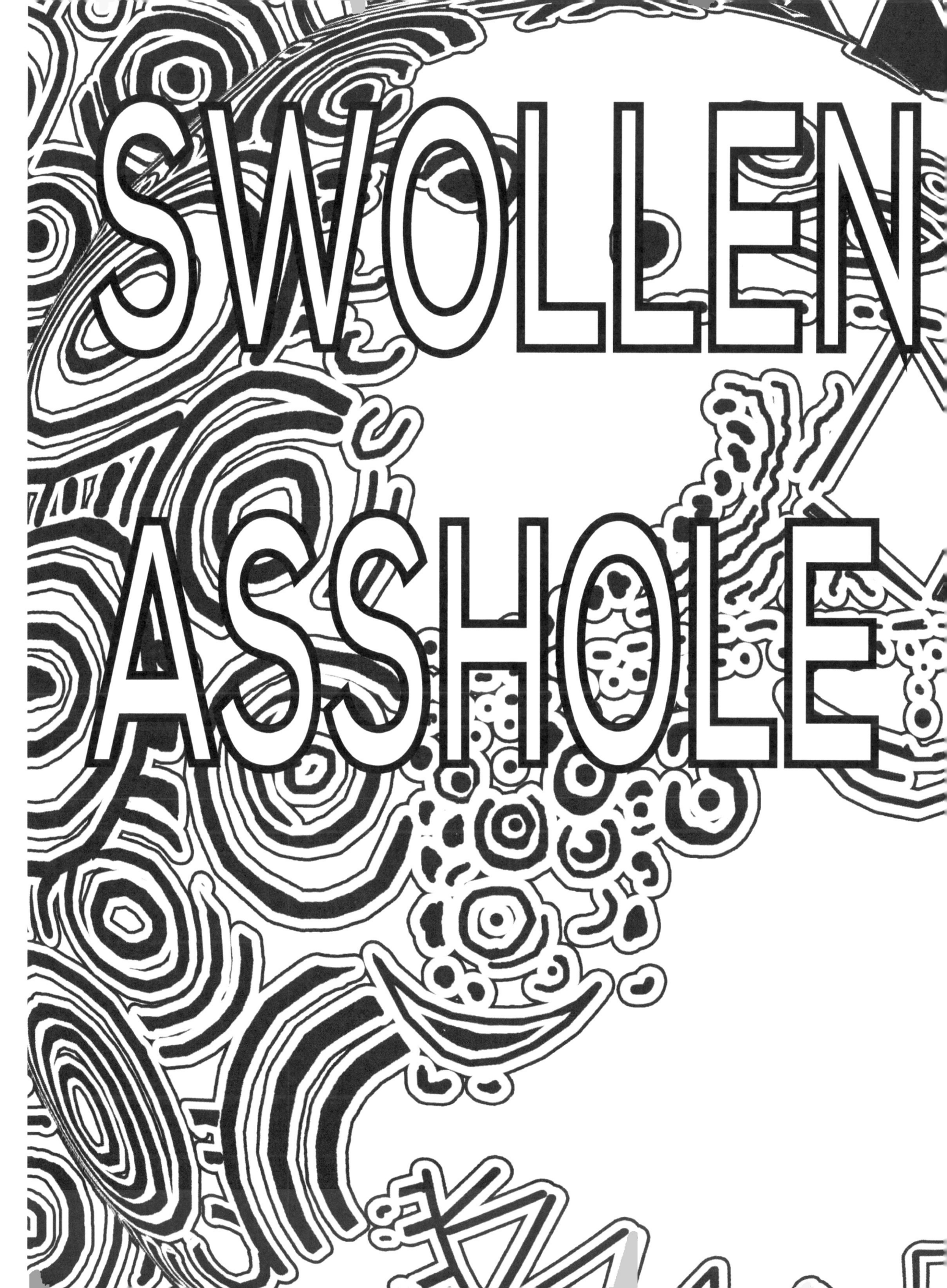

Stupid

Shithead

Dickriding

Slut

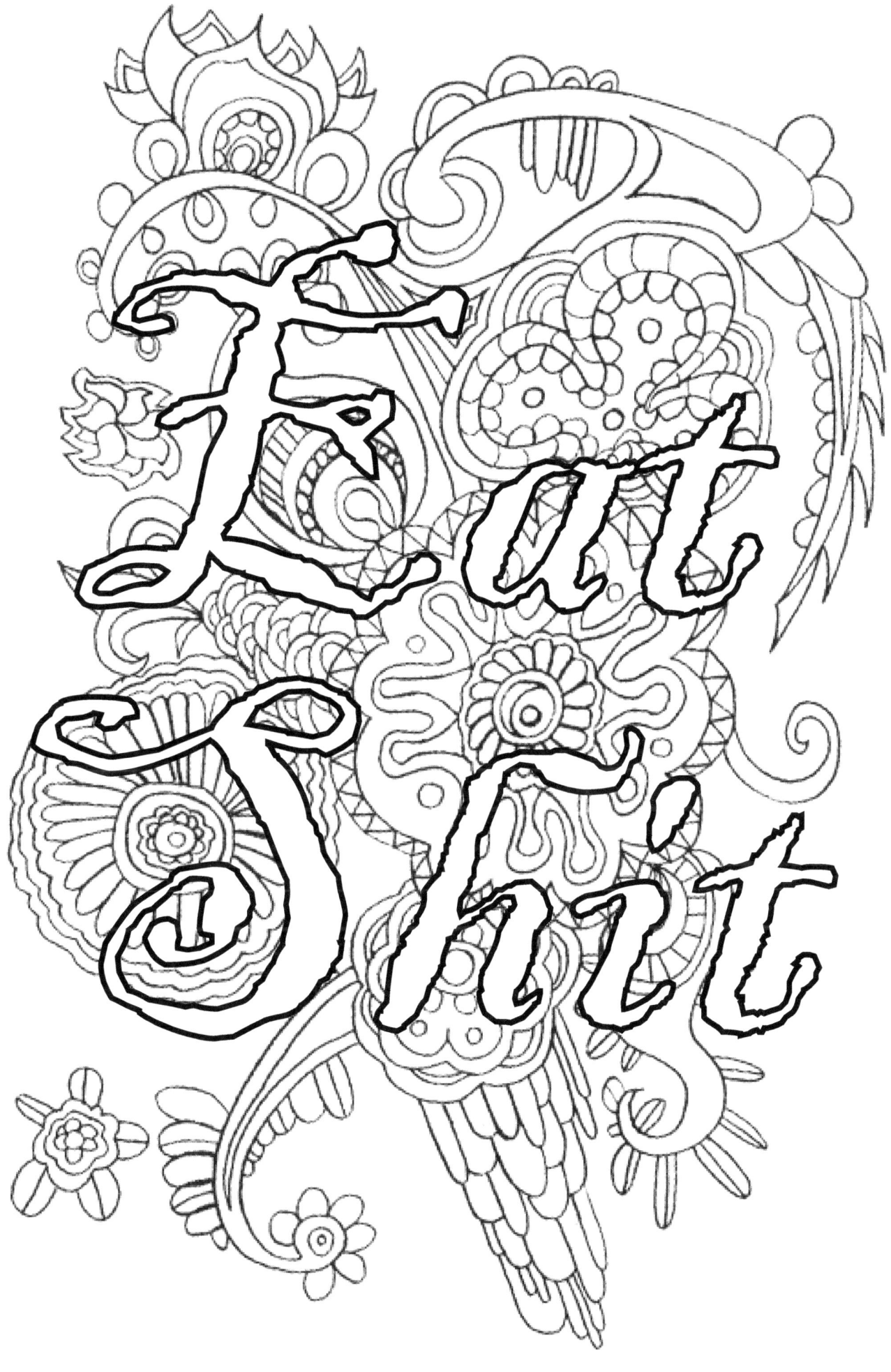

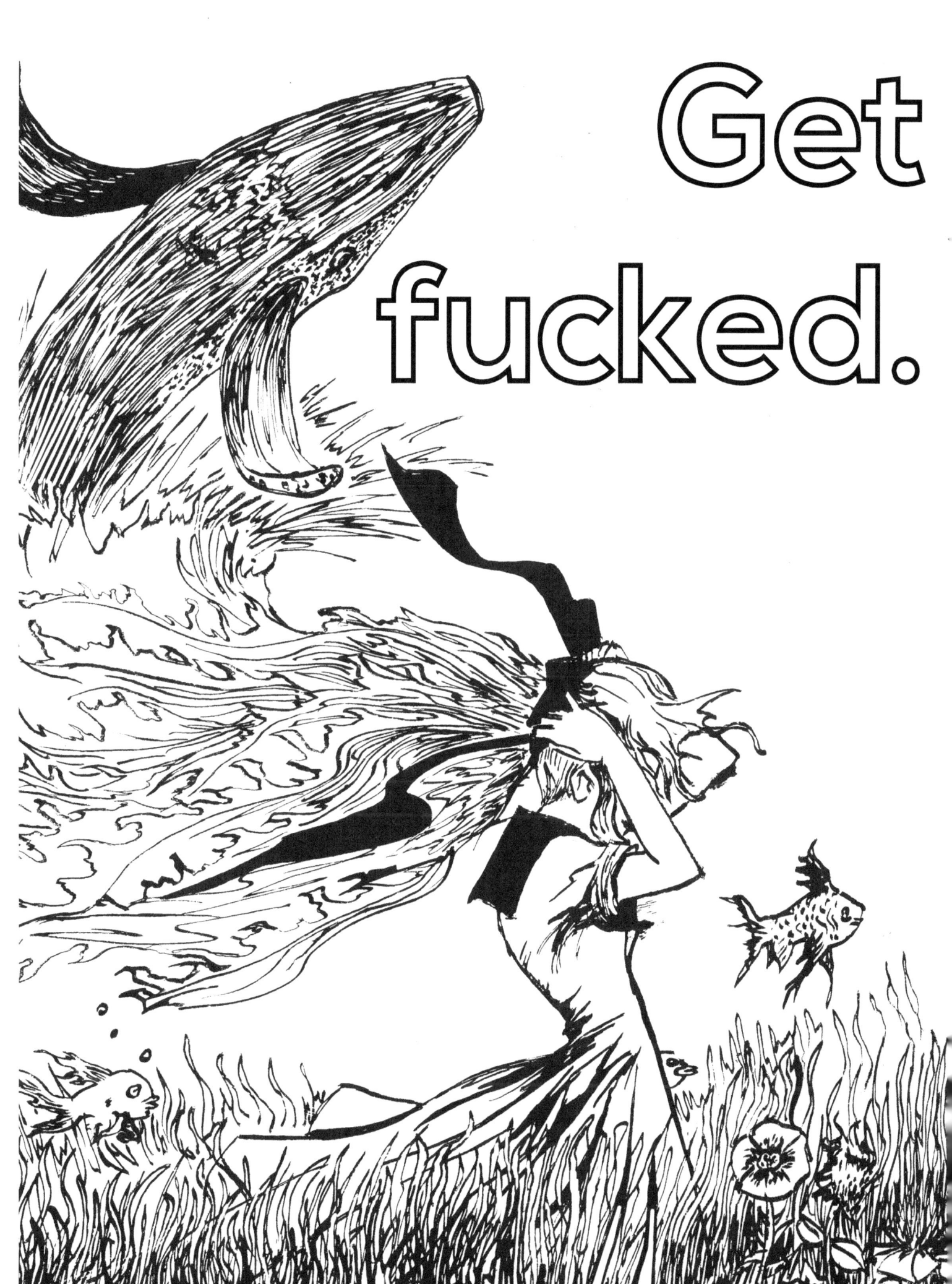

www.ingramcontent.com/pod-product-compliance
Lightning Source LLC
Chambersburg PA
CBHW082015230526
45468CB00022B/2295